DAVID SINDEN NIKALAS CATLOW

MACMILLAN

First published 2015 by Macmillan (hildren's Books an imprint of Pan Macmillan 20 New Wharf Road, London N1 9RR Associated companies throughout the world www.panmacmillan.com

ISBN 978-1-5098-0970-7

Text and illustrations copyright @ David Sinden and Nikalas (atlow 2015

The right of David Sinden and Nikalas (atlow to be identified as the authors and illustrators of this work has been asserted by them in accordance with the Copyright, Designs and Patents Act 1988.

All rights reserved. No part of this publication may be reproduced, stored in a retrieval system, or transmitted, in any form or by any means (electronic, mechanical, photocopying, recording or otherwise), without the prior written permission of the publisher.

135798642

A (IP catalogue record for this book is available from the British Library.

Printed and bound in Italy by Printer Trento S.r.l.

This book is sold subject to the condition that it shall not, by way of trade or otherwise, be lent, resold, hired out, or otherwise circulated without the publisher's prior consent in any form of binding or cover other than that in which it is published and without a similar condition including this condition being imposed on the subsequent purchaser.

Also by David Sinden and Nikalas Catlow

You can share photos and videos online instantly and they can be a really great way to connect with friends and let the world know what you're doing. But it's worth remembering it can be difficult and often impossible to delete pictures or videos from the internet entirely. Once you share something online, you lose control of it — it can be copied and shared further. And you're sharing it with more than just your friends. Anyone and everyone can see it.

Think twice before posting something you might later regret.

This book will spark your creativity and fill your social-media feed with creative, fun images.

Kespond to its prompts in any way you wish, whether on or off its pages: by videoing, photographing, drawing or making.

express yourself without need for perfection and post all images with the hashtag #PostThisRook

(apture yourself holding this book for the first time, before life changes.

Take a photo

and POST it with the hashtag

#POST THIS BOOK

Point this arrow. Snap a pic of where you are now. POST IT

(omplete and share this: #POST THIS BOOK

Fill this square in any way you like

Attempt to draw a PIG IN A WIG POST THIS BOOK

Post a photograph THIS BOOK

(reate outside this book.

Paint an egg.

Share it Post Book

Grow this seed POST THIS BOOK

WHAM BAM KERPOW!

Express yourself as if you lived in a comic

Tag a friend

TRANSFORM YOUR SELFIE #POST THIS BOOK Point and snap

Respond to each of the prompts below. (reate on the pages of this book or outside it, using any medium you like

ADD EYES TO ANY OBJECT

A view through a cardboard tube

*POST THIS SHOUTY EDDIE

Make him shout

IN MIRENIS

HILLING

HEALTH.

& SNAP #POST THIS BOOK

FILM THIS FILLING UP

(ustomize then hold your personal mug

1

While creating with this book, treat every in-between or leftover space as a canvas, however small.

Doodle, pattern and colour around things. Fill up the background

#FverySpaceUsed

Show a worthless thing you love

RESPOND ON GRAVITY IN ACTION Decorate a branch Hat on a pet

WHAT DOES A SNIGLET
LOOK LIKE?
**POST THIS BOOK

Stack your books

#POST THIS BOOK

Make a new profile pic

Post found
numbers
#LookForNumbers
(reate a foot monster

Add another cate to the internet

O Point and snap

Express any of these: TOPPLE! SPIN! JUMP!

(apture imagination in this jar

Point your camera upwards. Find art in the sky

POINT AND SNAP

Point your camera downwards. Find art on the ground

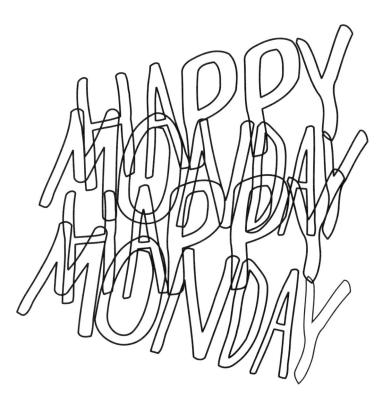

Decorate and share on a Monday *PostThisBook

RESPOND OF

Show the adventures of a toy

Rearrange flowers Bling

USE A NEW APP OR EFFECT

e.g. levitation, panorama, pop art, slow mo, POST THIS BOOK

eate using s

Depict a song without using words THIS GUESS MY SONG

POINT AND SNAP

ND OFF **T**HE **P**AGE

Show something out of place out of place.

Turn anything into a unicorn #SeeTheUnicorns

FROM A BUG'S POINT OF VIEW

(elebrate a celebrity #POS

An image inspired by THIS BOOK googling the word PATTERN

(REATE A PATCHWORK #TheMassiveBlanket

NAIL ART #POST THIS BOOK

Your hand here

RESPOND O

Be misguided with make-up

FILM a THUMB WAR

in costume 🦥

A thing in multiple

Depict yourself as an animal

LET LOOSE **POST THIS BOOK

DRESS ME #Post THIS BOOK

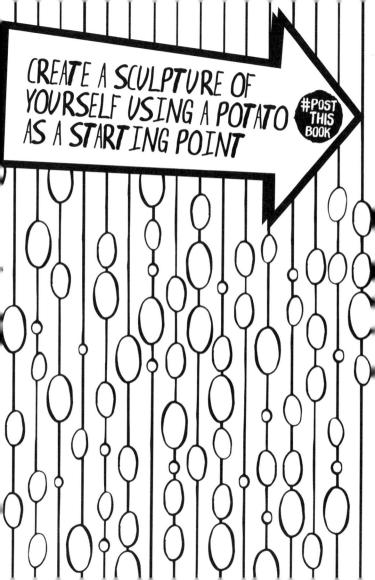

IND OFF **T**HE **P**AGE

Display your materials

FAKE A TATTOO YOU'D REGRET

Show lines on 11, your hand

An Image from My Generation

HPOST Who remembers this?

POINT AND SNAP

Share a four-word poem

Post this to praise someone

GROTESQUE PORTRALI

RESPOND OF

REPEAT

Brappiness 1

Film one action.

LOOP IT

#PostThisBook

Me when I looked different

TANGLE THIS PAGE FROM BOOK

Take your camera for a walk

RESPOND OF

Add colour to a **T**-shirt

Add speech bubbles to an image

MOSAIC FROM FRAGMENTS

Divide this page #POST THIS BOOK

SHO! SHO!

& SNAP #POST THIS BOOK

Add flowers here.

Post this, tagging
a friend who
deserves flowers

#POST THIS BOOK

RESPOND O

(apture something beautiful

MY FACE AS A CANVAS

Over-decorate
a cupcake

Find love for your pet at #POST THIS BOOK

PET'S DATING PROFILE

X

Depict a fictional character from a game, book or cartoon

LOOK!

IT'S A MEME

#POST THIS BOOK

Animate an inanimate object

#PostThisBook

The same but different

Photograph someone taking a photo

BUTTONS

VD OFF THE PAGE

POINT O

USE THIS PAGE TO CONTINUE ANOTHER PICTURE #POST

THE OOPS! PAGE FRIED PAGE

1. Finish your life's To Do list 7.

Remove your shoes

Record a day #POST THIS BOOK

#POST Gummy Bear THIS Horror Show

RESPOND OF

Record laughter

FIND A FACE IN AN OBJECT

#POST THIS BOOK Show the death of a tomato

VIDEO A PART
OF YOUR
POST ROUTINE

EXPAND AND COLOUR POST THIS BOOK

ND OFF THE PAGE 😤 💿 /// 🦠

[ompletely

cover an

object in colour Fake an antique photo

RECORD PIECES OF A PLACE

RESPOND OF

SHOW A COLLECTION

Turn a thing SCARY

Refashion fashion

Express any of these: SPLAT! BURST! WOBBLF!

IMITATE SOMEONE ELSE'S #POWORK THAT YOU LIKE

Beach art W

Yesterday's technology

PRESS

YOUR FACE

Stick-man tragedy #POST THIS BOOK

Start Here.
Go beyond the edges of the

MESS WITH THE SCALE OF THINGS

Use a window as a frame

(reate a ghostly effect)

Devise a tabletop obstacle course

Photograph reflections

Attempt a tricky throw. Record it

Photograph a secluded spot

ime-lapse a

A close-up paint a leaf

RECORD A
BUILDING ***

ND OFF THE PAGE

POST THIS BOOK

AN IMAGE INSPIRED BY GOOGLING THE WORD COLOUR *POST THIS BOOK

Build a badly made model

Capture
SHADOWS

#POST THIS BOOK

FILM AN ANIMAL Post This Rook

Use a boot as a vase

Zombify #POST THIS BOOK something unlikely

PAG